World's Greatest Artists

World's Greatest Artists

By

Walter J. Schenck

iUniverse, Inc.
Bloomington

Text Written By: Walter J. Schenck, Jr.
All Text Copyright By: © Walter Joseph Schenck, Jr.
Illustrations By: John House As Work For Hire for W. J. Schenck
Illustrations Copyright By: © Walter J. Schenck, Jr.
Clip Art: Public Domain

iUniverse books may be ordered through booksellers or by contacting:

iUniverse
1663 Liberty Drive
Bloomington, IN 47403
www.iuniverse.com
1-800-Authors (1-800-288-4677)

ISBN: 978-1-4620-0734-9 (sc)
ISBN: 978-1-4620-0735-6 (ebook)

Printed in the United States of America

iUniverse rev. date: 03/25/2011

To The Curious Minded –
May You Never Limit
Yourself In Anything You
May Want To Accomplish

Commentary On Walter Schenck

Concerning World's Greatest Artists and Handbook of Jesus' Parables:

V.P. & Editor In Chief: "They are quite impressive."

Concerning The Birdcatcher:

Prof Wilson wrote: "His work is outstanding...He truly succeeds in making one want to know why and what next. He has a power of psychological involvement which is exceptional."

Prof Carkeet wrote: "A breathtakingly good story -- a strong, violent, moving tale set in Vietnam...high quality in style and intellectual intrigue with a visionary streak."

Another University Teacher: "Your work is often of astonishing brilliance...some of the most powerful writing I've ever seen in a writer...I would expect you to become a writer of serious note...I am deeply impressed by your book."

And another: "Powerful writing...excellent action writing...amazing talent."

Concerning Shiloh Unveiled:

It is truly an amazingly good work with impressive writing skills that immediately place it as a valuable work to own. It places Biblical principals and events in a fresh perspective. This is an impressive work that appears to be another Testament. Historically it is an accurate rendering with an incredible spiritual blessing.

Concerning First Voices:

I've often wondered what direction a writer such as Mr. Schenck would take after his warrior's tale. I never expected this spiritual road. His enormous undertaking dazzles me. His venture into the spiritual field of writing is an extraordinary one. His in-depth knowledge and research presents a marvelous

and scholarly work in the novel's vein of story telling. I always thought Mr. Schenk as a brilliant writer – but he is actually more that. He has transcended to a level that only giants can reach.

This booklet contains a brief history of 10 artists along with 20 black & white illustrations representative of their accomplishments. Learn about the lives of Watteau, Velazques, Gauguin, Turner, and 6 other major historic artists in an exciting and original composition that will inform and delight the young reader.

Walter Schenck, one of America's foremost writers, authors this book. He has written several epic and brilliant novels.

Antoine Watteau

Antoine Watteau served Louis XIV of France, painted for him in a more refined, more elegant style than France's previous artists.

He was born on October 10, 1684 in Valenciennes in the Flanders and died on July 18th, 1721.

Watteau, unlike many other great artists, preferred a modest, remote life style. Perhaps due to his sufferings of tuberculosis Watteau personified a lonely existence troubled by depression and contrastingly, by hard work that served to provide him a world of grand fantasy, far removed from his troubles. His inner-world vision, in turn, provides for us wonderful scenes wherein we also desire to reside.

Watteau, in his youth, trained first under Jacques-Albert Gerin in Holland. Later, when he was 17, he continued his tutelage under Claude Gillot in Paris.

Though he did study with famous masters, Watteau's style reveals how he had taught himself an appreciation for the Italian artists Titian and Veronese,

whose visions he had incorporated through the usage of great coloration and intense atmosphere.

Watteau, however, suffered from tuberculosis. Despite this, he drew his works during the last five years of his life – usually during the morning. His art became for him a personal salvation from his pain, and in his art, even though he was an introspective, frail, and brooding person, he realized a greatness that endeared him to the world.

The Peasant Dance
1702

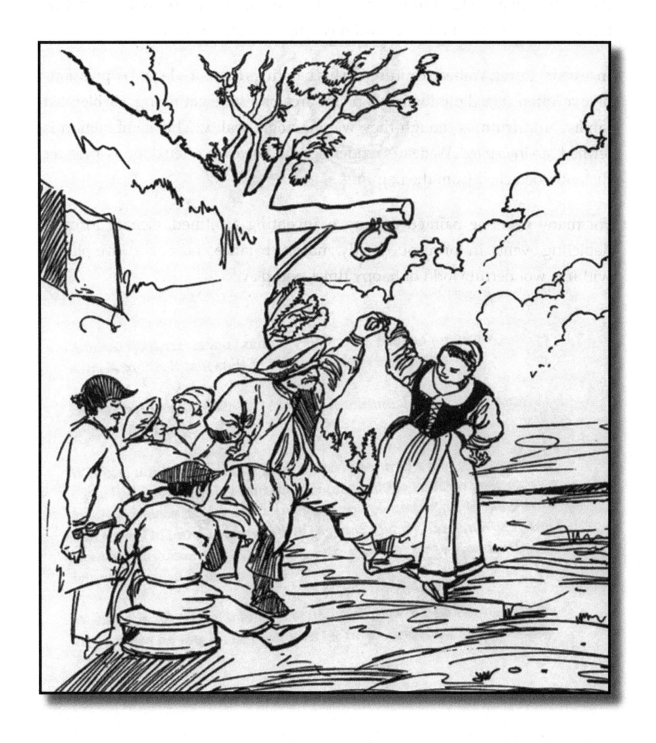

The Pheasant Dance painting demonstrates Watteau's ability to paint the Flemish life-style as enhanced by his own vision of a dancing pair enjoying themselves in a poetic country setting. The Peasant Dance drawing style was termed *fetes galantes*, a French word meaning "elegant festivals."

In broader terms, Watteau captured in his paintings the soft, elegant expressions of love, often staged outdoors in a picnic area or festive gathering. He blended fantasy and truth as though they were a single reality. This combination is termed "an interplay." Watteau's rendering was, however, often done as a viewer distantly detached from the painting.

For many years he painted in France, inventing a refined, elegant form of depicting events, in forms of comedy, musical balance and poetic love placed within a wonderful world of happy times and play.

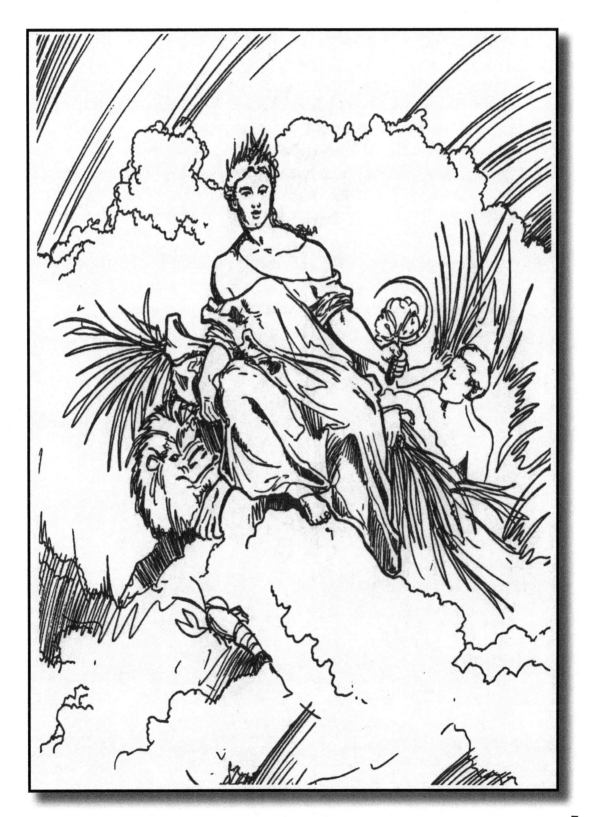

Watteau's second painting in this book - Ceres - captures the Romans fertility goddess Ceres watching over a summer field. It was painted in 1716, again interplaying fantasy with truth.

Diego de Silva Velazquez

Velazquez was born on June 6th, 1599 in Seville, Spain. He was from an aristocratic family, the *hidalgo* class, and later, in King Philip's court, rose to become a knight of the Order of Santiago on November 28th, 1657. Less than a year later he died of malaria on August 6th, 1660.

For a great many years Diego lived in the royal palace and was able to marry his mentor's daughter, Juana. Their marriage lasted for 43 years. His first masterpiece was shown when he was 19.

His style was realistic and yet, experimental, often showing concern to accurately depict the people he was painting. His portraits can actually be compared to a contemporary photograph: his eyes keenly discerned color-hues, variant gray and black shades and he trained himself to sharply define his brush to bring out distant, near and middle objects.

The Watershed
1619

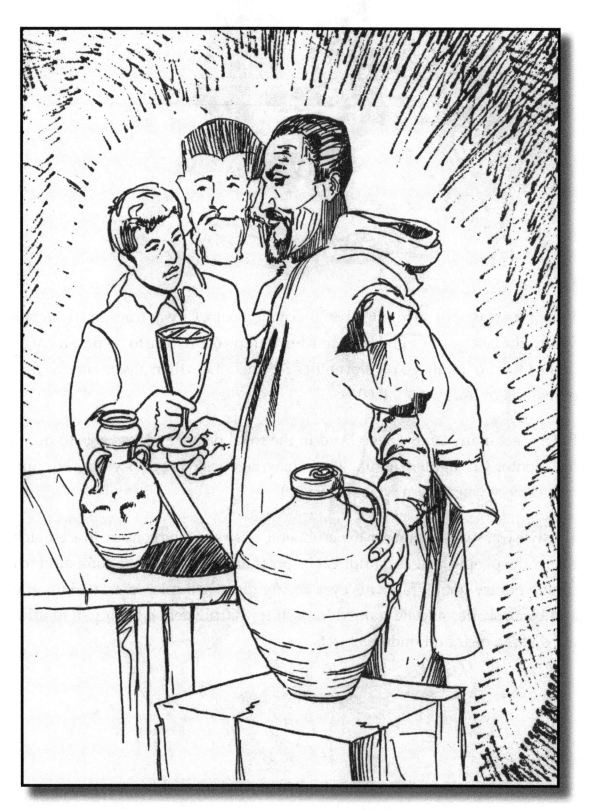

This painting by Velazquez depicts the necessity of bringing in water from the remote outlying areas of the country to the city of Seville during the intense summer seasons. The water was stored in clay jugs and sometimes it was sweetened with figs or rosemary. As can be seen, the men are relaxed and clay jugs bulge and drip.

Forge of the Vulcan
1630

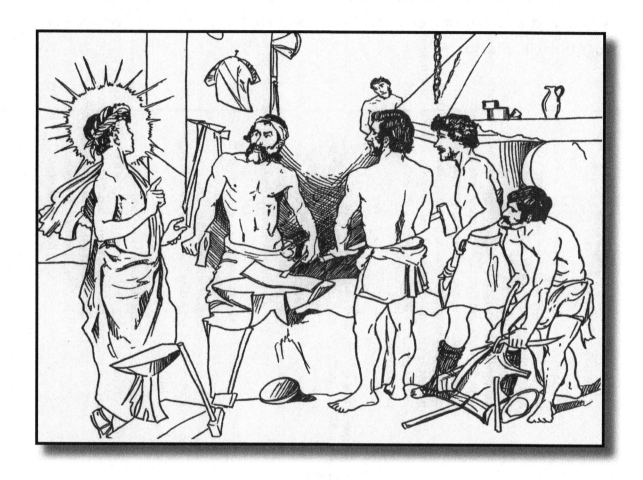

In this painting, Apollo, the Roman sun god, is gossiping with the god of fire and metal works: Vulcan. Velazquez depicted the plot, illustrating that Apollo's wife, Venus, is in love with the god of war: Mars. The tools and working materials are finely detailed.

He painted this during a turbulent time between Spain and Italy, and even though born a Spaniard, his desire to learn from the Italian artists, Titian and Caravaggio, overcame national prejudice.

Yet Spain had conflicts with other countries as well. During her problems with Flanders and France, Velazquez was assigned by the royal court to draw grandiose subjects. Keeping personal integrity, he drew the kings and knights

in realistic terms, favoring truth over fiction. The chins were honest as were the cheeks and lips and body features. As can be seen even in this picture—the gods are viewed without the extreme masculinity of other artists.

Paul Henri Eugene Gauguin

Gauguin's life was a testimony to his own selfish ambition. He was born in Paris, France in 1848, and even though he was 5 feet 4 inches, as a youth he traveled around the world as a merchant marine seeing the islands that he would forty years later memorialize in his paintings. Besides sailing around the world, he served in the Navy during the Franco-Prussian war, and in his forties, swung a pick on the Panama Canal project.

By a turn of events, though, at age 23, he became a stockbroker in the Paris Bourse, earning a considerable sum of money. During the 11 years he had worked in the Bourse he practiced his musical instruments and kept devoting his painting skills for the eventual pursuit of fame in the word of art.

When he was 34 years old he finally declared his intent to be a painter, quitting his job without a single successful sale or public endorsement. He left his wife and five children and after a short time, began traveling around France to paint peasants and the countryside of Brittany. After honing his skills he pursued his dreams to live in the islands, dying at the age of 54 at Hiva Oa, Marquesas in 1903 from disease and self-neglect.

Despite the truth of his life, he became a legend among office workers who dreamed the dream of an easy life in the islands without conflict or need of food. In contrast, Gauguin couldn't eat unless native children brought to him the food from the treetops and from the mountains and lagoons as it required tremendous strength and effort to live in the islands. Yet, one thing became certain, Gauguin was a great artist and the ideas, which he embellished on his canvases, became the foundation for modern artists worldwide.

As a member of the symbolist group of artists and poets, whose views were that reality existed in dreams and hallucinations, Gauguin was financed by them to travel to the islands, and there he advanced his crafts, indeed, attainting the greatness he sought – but long after he died.

Actually, a sliver of his true greatness began to emerge while he was living in Brittany. Gauguin's canvases imparted rich, bright earth tones, representing emotions and ideas, which were harmonized to reflex a continuous, thought pattern. While on the islands his hues became important for the colors' own values, lessening their once symbolic gestures. The golds and yellows and browns on green and violets on purple created a wonderful balance. What had once envisioned ideas came to encompass shapes of life similar to a musical discourse – a canvas symphony rendering abstract harmonies.

The Yellow Christ
1889

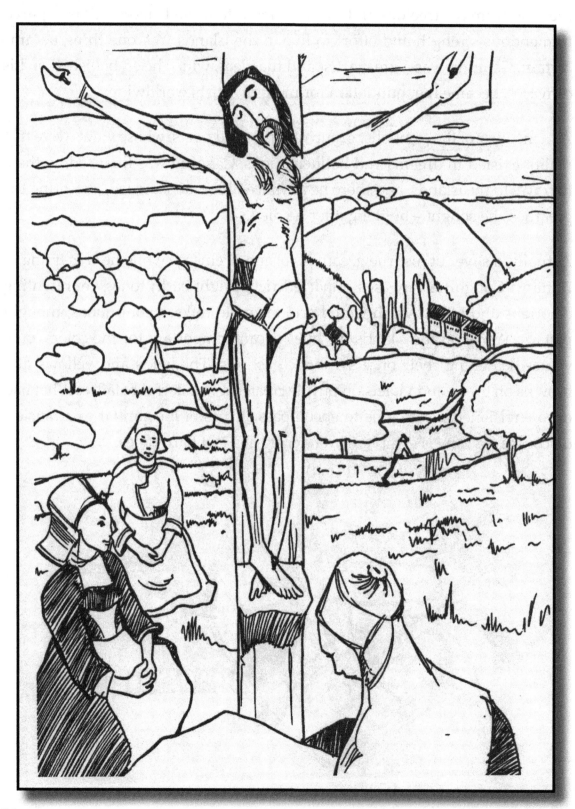

Perhaps to emphasize Jesus' oriental background or to stress his Jewishness, Gauguin painted Jesus' body yellow with overt cheekbones and sharp eyes. In the left foreground we again encounter the Breton women whose prayerful devotion may have been responsible for the mystical image to appear before them. The Yellow Christ is set before a grand farmland that seems calm which encompasses a barn and a road that leads to a village. Notice also the boy who is playing, climbing over a fence. This wonderful balance was created with rich earth tones, varied among gold and brown hues with the women wearing their usually dark green dresses.

La Belle Angele
1889

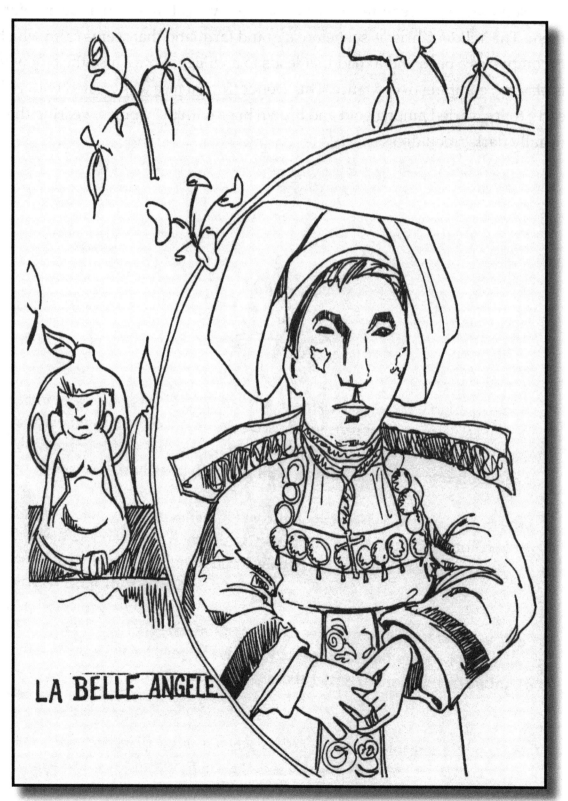

LA BELLE ANGELE

The couple that had received it as a gift from Gauguin originally refused this painting of a young lady in a Breton costume. He presented this gift to them because they had provided free meals to him.

Breton women typically wore unadorned dresses that were usually dark green or black or brown. Their dresses were long and their collars were starched stiffly around their necks. Their white caps and aprons were supposed to symbolize their austere manners and reflected the degree of their religious beliefs: chastity and loyalty that was reinforced through their superstitions and false imaginations. Ironically, their traits typified the island girls whom Gauguin wound be painting in the later years of his life.

Peter Paul Rubens
"Pietro Paudo"

Rubens, perhaps more than any other artist, reflected the opulence and the viewpoint of the nobility of his time: their sensuous cravings; their lust for possessions; their larger than real visions of themselves; their strict belief in hereditary privileges, divining their right of authority and dominance.

Rubens, though he mingled in the privileged classes of the day, was not himself an aristocrat. A problem that King Charles I of England tried to resolve by bestowing upon him Knighthood for his diplomatic peace efforts from 1629 – 1632.

Though he was knighted in England, he was actually born on June 28th, 1577 in Siegen, Germany of refugee parents who had escaped from Spanish Netherlands because of religious persecution and impending civil war.

Amid the intense, hostile, uncertain background of Northern European affairs, Ruben's family, after his father's death, resettled back into Antwerp when he was 11 years old, and with their return to Holland, Rubens aligned himself with Dutch nationality. It should be said that Antwerp, during Ruben's fathers

time, was a thriving commercial center that had by Ruben's own time become a city of desolation and dereliction and foreboding anger and insecurity. Ruben's, however, grew up to be a well-balanced and generous man with polished manners who through hard work and diligent application of his talents to the task, came to triumph as the cornerstone of creative genius of Baroque Art.

Cultivating and enriching his talents methodically over a period of time in various European countries, Rubens came to possess a rich intellect and a keen observation that gave birth to the Baroque art form – a painting style emphasizing curvature and ornamentation that embellished the richness of colors flooded with dramatic contrasts in light and shadow, distinguished by uncanny flesh tone renditions of buxom women and mythological figures that could mesmerize the viewer into believing that the painting was in fact a vibrant moving picture.

At times, Rubens stressed man's potential happiness in his landscape paintings and at other times he stressed large-scale epics of Greek and Roman pagan symbols that were calculated to intertwine with Christendom's Counter Reformation values, becoming in itself a harmonic representation of a world engulfed by fairies, angels, nymphs, nudes, exotic animals, alongside Kings, Queens, Princesses, Knights, and aristocrats. His specialized art form depicted masculine heroes and good courage that would finally triumph, even in the midst of a grueling battle that tolled on the characters extreme sufferings and callous horrors. Yet, always, the end result became a magnificent justification of man's truest glory and hopes and such triumphs became allegorical representations of the aristocratic classes. The magnificence of his paintings, especially the war scenes and hunting escapade, popularized the usage of his "S" curvature that came to delight the viewer, causing him to involuntary focus his eyes and true concentration on the important action and events of the picture, and to turn his attention to discovering the hidden symbols or messages contained within the confines and context of the depiction. His paintings thus served to become a fabulous intellectual device for the people of his time – becoming in fact, vastly commercialized through manufactured replications in etch and in imitation.

His vitality and passion ushered in the *Golden Sunset of Flemish Art*. His advanced accumulation of knowledge allowed him to discuss the major philosophical questions of the day with other great European thinkers and his ability to maintain a level, common sense approach led to his appointment by the Netherlands King in 1629 to become the secretary to the Royal Council of Spain. This title permitted him to approach with grand influence a negotiated peace settlement between his country, Spain, and England.

Rubens married twice. The first time he was 34 and his bride, Isabella was 17. His second wife, Helene, was 16 and he was by then 53. His life appeared relatively easy, without great distress or struggle. He became enormously wealthy with a beautiful house n Antwerp and a chateau in the country. He pioneered mass distribution of art through etching and his school reproduced many of his great works in addition to many other famous painters for-would-be collectors. His own wealth allowed him to also become a collector and a connoisseur of art. Yet, when he was in his mid-fifties, he became afflicted with gout, at times hampering his ability to work. Later, he developed arthritis in his right hand. He died on May 30th, 1640 of a heart failure.

The Straw Hat
(Le Chapeau de Paille)

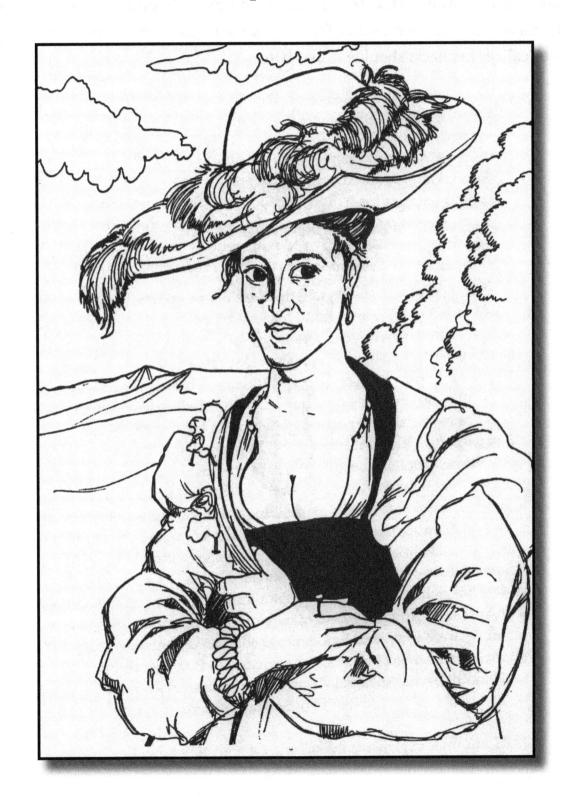

This is a painting of Susanna, daughter of Daniel Fourment, and sister of Ruben's second wife. Actually, the hat wasn't straw, but a heavier felt. The hat was used by Rubens to illustrate his inverted upward motion curve, bringing attention to Susanna's eyes and face and her smooth completion. The viewer also realizes her neck, shoulders, and hands.

The Four Philosophers

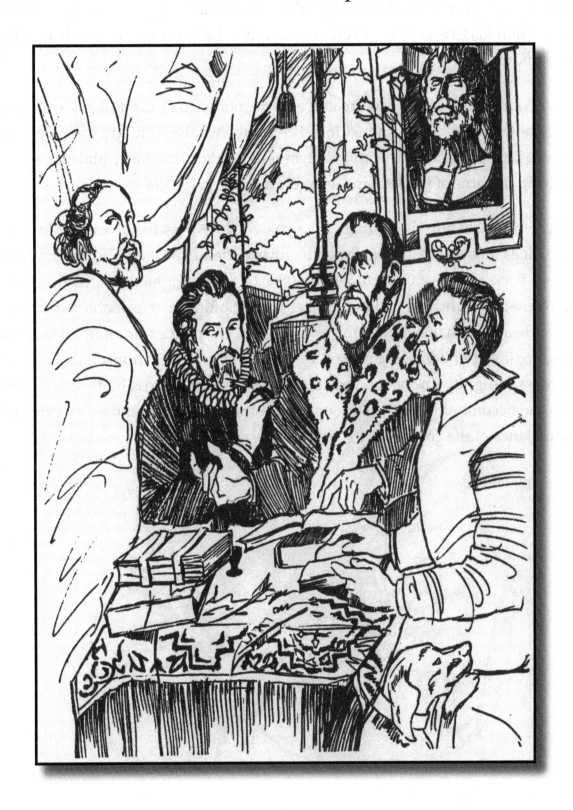

In this painting we see Jan Woverius, a scholar who is on the right side; then Justus Lipsius, a Stoic philosopher; then Philip Rubens, Peter's older brother and a famous Classicist intellectual and author. Last, we see Peter Rubens who is standing up.

The Four Philosophers was created as a memorial to Philip Rubens who had died at the age of 38, in August 1611. Peter Rubens raised Philip's son. The bust above Lipsius' head is Seneca, a Roman philosopher, dramatist, and statesman during the time of Christ. Lipsius wrote a book on his life.

The Stoics held a tradition that encompassed their lives life according to a set of values that they had established to govern their existence. The declarations went back to Zeno, its founder in 308 B.C. who taught that all things are governed by unvarying laws. A believer should be reasonable, virtuous, level headed, unaffected by the external world's politics or affairs. He must endure life's periods of sufferings, bearing the pain within himself so he could maintain dignity and valor and calm in the face of impossibilities. The stoic should become aloof to the various world pleasures so to compose an external semblance of the good in man – the virtues of life.

Vincent Willem van Gogh

Van Gogh was an artist who struggled against natural phenomenon. He never painted anything as it actually was, as had Rubens, Velazquez, or Rembrandt – but painted things as to how they may actually be should the light and law of motion be somehow changed. Or, theoretically, how God may be viewing nature and man after the Edenic fall. Everyday objects, such as a chair, a bed, or an entire room, became redesigned and trans-collected into a new avenues of expression and sight with new laws of motion and contortion. He created in his paintings a re-conception of nature, illustrating motion, light, and man as a tri-universalism of existence.

The tremendous grandeur of his expressions are seen in a fluid brilliance that caught man and his environment as no one else had captured before. Life, in Van Gogh's paintings, appear to speak of a commonality and of an outgrowth of all things – a juxtaposition of everything as viewed from a single creator, perhaps God, depicting how things now are, and perhaps are to remain until God decrees a return to Eden. Van Gogh's art thus envisioned for the temporal man a vigorous concern that, coupled with nature, becomes inseparable from love and the manifest need for companionship. In his paintings, even with a chair, there is nothing alone. Everything is a part of something and all is

entwined in intimate intricacies intriguing the secret facets of our visions of all things living. Everything is an energized reality that serves to manifest God's own reality. Life's once harmonic balance became hidden by the fall of mankind, and perhaps Van Gogh seeks to declare a new testimony of God that couldn't be thwarted by any religious council or established correctness of procedures or rules or scholarly testing.

The excursions and fanatical religious outpourings of his youth – which the coal-miners rejected – found a new vein of undeniable encountering in his paintings. A shared and personal truth personified through the brushstroke as never before presented by any other artist. The quest for companionship and love that was turned away now forced people to become fixated by his art; not through rendering grand Biblical themes, but by reestablishing the worthiness of sunflowers and open fields and trees and man's involvement therein. Similarly, his 40 self-portraits shouted to the world his existence and that by viewing him, the viewers must recompense him for their previous chastisement, thus reconciliation is achieved with the world – his friendlessness and loneliness – the conflict of his soul – is forgiven. The new earth, which he alone saw, expressing the human condition, became more important than the person, and through art, human tenderness coupled with simplicity, could become the bond that forsakes denial and rejection.

At age 16 Van Gogh began his painting career by training to be an art dealer. His task was to reproduce famous artworks for his uncle's firm, Goupil & Cie that was headquartered in The Hague, Holland. When he was 20 the company transferred him to London, England where he met his first love, Ursula, who in turn, rejected his heart's announcement for their marriage. Eventually, Van Gogh's behavior became a nuisance to his friends and family. He was soon transferred to Paris where he became careless in his work, resulting in his removal from the firm. At 24 he desired to follow in his father's path and became a minister. In Amsterdam he lived with another uncle who happened to be an Admiral of the Navy. Unable to learn the Greek verbs that were absolutely necessary for him to master so he could pass his ministry exams,

he resorted to whipping his own back and to sleep on the cold wintery floor of his room. He slept without so much as a blanket.

Unable to pass the religious exams, he nevertheless declared himself a minister and went to preach to the coal miners who worked at the city of Borinage in the country of Belgium. After a short period, he was summarily dismissed for practicing too zealously his religious beliefs – a function that he took too literal. He refused to return to his home. Instead, Van Gogh buried himself in his thoughts. He took a hiatus from the realities of life – the histrionics a blemished failure – and emerged from Borinage's coal mines determined to be an artist. He was now 27 years old.

For the next five years Van Gogh taught himself to paint. His paintings steadfastly matured. His refined craft gave emphasis toward the yearnings to discover the inherent affections that each man has within himself placed in the context of universal existence.

He trekked from Antwerp to Paris. In Paris his art continued to broaden, transforming within two years from one realm of reality to a completely different realm of reality. His stylist approaches shifted continuously as he tried to garner that final, perfect brushstroke. His colors became brighter, more intense, with a greater depth of *impasto*. His art form took an appearance of invigorated energy that re-harmonized old expressions into something at once dissimilar – and yes, at times frightening. Expressions in portraiture and landscape burst forth from his imagination to the canvas at an unprecedented speed for artists. Later on he resettled in Arles, France – an ancient Roman city that was once the capital of the country. There, his art productivity enshrouded his consciousness with brilliant expressions that became masterpieces of creativity.

Yet, his melancholy intensified. One day, in a state of despondency, he attempted to attack his roommate, Paul Gauguin. He retreated and in the aftermath, he sliced off his left earlobe, which he gave to a prostitute as a gift. In his new prolonged isolation and desperation for friendship, Van Gogh began imagining voices and sounds. He started to believe someone wanted to poison him. The

children made fun of him and the townspeople repelled his friendly encounters. Finally, the police arrested him. He was placed inside a mental hospital. From there he was transferred to saint-Remy Hospital. A year later he was released. Through his brother's efforts, he came to live at Auvers-sur-Oise. There, he shot himself in the abdomen. He died 36 hours later. He was 37 years old.

Fishing Boats on the Beach at
Saintes-Maries-de-la-Mer
June 1888

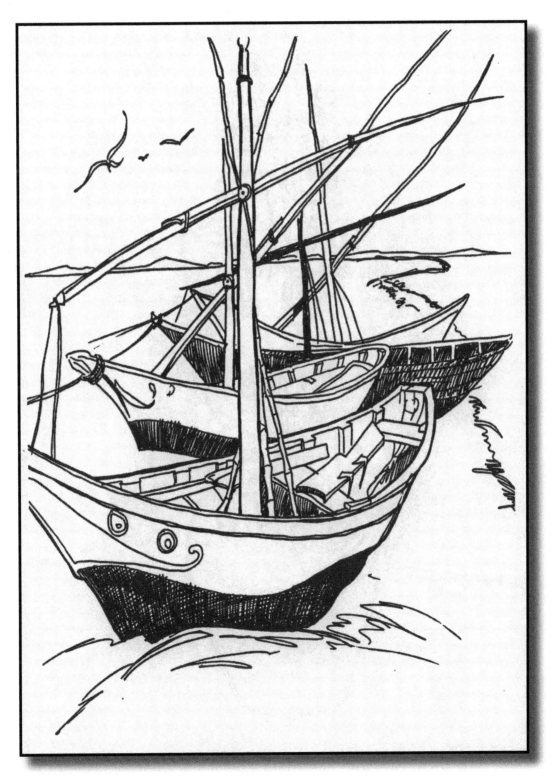

This drawing was completed during his stay at the mental hospital in Saint-Remy. As can be seen, even though he was in a mental hospital, his drawing was clear and fluid and the expression intent.

Sunflowers
August 1880

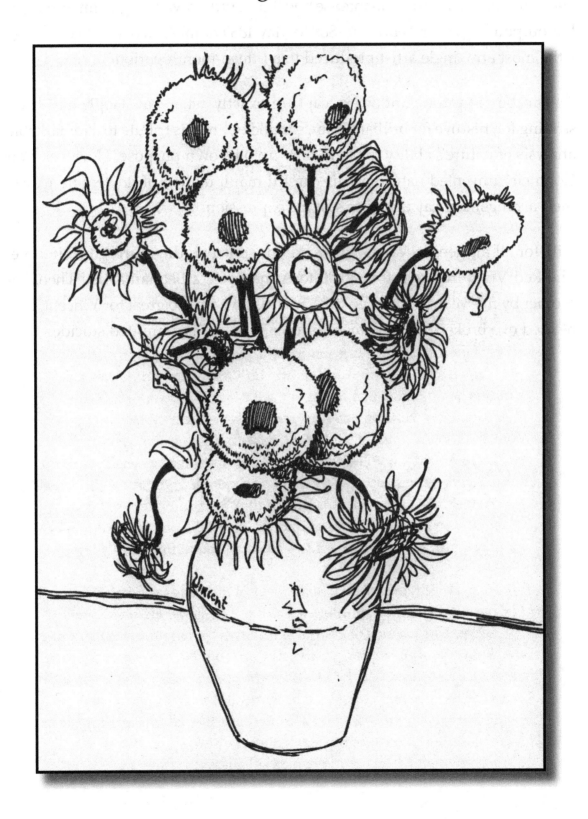

This painting pays tribute to Arles' rich countryside and elegant colors. Rather than paint Rome's past legacies, he chose the invitation of the fields. The sun was brilliant, giving Arles an intense hue that captured Van Gogh's imagination. His outpourings from February 1888 to May 1889 numbered over 200 paintings – the most any single artist produced in a fifteen-month period.

As can be seen, the sunflowers capture exactly what Van Gogh had been striving for, his love for brilliant color, simplicity, and his tribute to a remarkable analysis of nature's ability to blend man unto its own purpose. However, Van Gogh circumvented nature by his careful manipulation of flowers in a vase, their arrangement calculated to suit his expression.

Still, for all his genius, Van Gogh's sold only one painting during his lifetime. The Red Vineyards sold for $80.00 to Anna Bock, a Belgian artist. Theo, his brother by five years, supported him, and his love was so great for Vincent, that he died of a broken heart six months after Van Gogh committed suicide.

James Abbot McNeil Whistler

Sometimes a man must work years – decades – and face unfair criticism, and even ridicule before public awareness and the circumstances of time allows recognition of a man's talents and importance. Denial and disapproval – especially in the light of talent and genius – can either circumvent one to reside in darkness, or it can produce a defiance that demands recognition regardless of the public's disapproval. Such survival mechanisms were incorporated by Whistler, allowing his subdued art tones, his harmonic balances and his elegant nocturnes and his carefully composed arrangements to triumph against the once resolute decrees of Pre-Raphaelites and Victorian art principals; becoming a pronounced instigator – in manner and in court – of the true modern art form.

James Whistler was born in Lowell, Massachusetts on July 11, 1834 and received his early education in Russia where Sir William Allen of England recognized young James' genius. He agreed to sponsor him at the Imperial Academy of Fine Arts – Russia's most prestigious school. After Whistler's father died from a heart failure which he suffered as a result of a cholera infection, James returned to the United States where he found a new sponsor: Daniel Webster. James, a constant joke maker and player of tricks upon others, was nevertheless permitted

to continue his education at West Point. Unfortunately, his unwavering tactics finally forced Commandant Robert E. Lee to expel him during his third year of school. In 1855 James' brother, George, took up the reins and sponsored him to a trip to Paris. There, he moved into the Latin Quarter of the city. Paris, during those years, was the art center of the world. Despite his continued resorting to antics, he learned to fine-tune his skills. He constantly worked at his art craft and etchings. Eventually, it was his art etchings that led him to become recognized as one of the world's finest craftsman. He created fabulous masterpieces with flair of understatement, reminiscent of Oriental Art.

Symphony in White #3:
The Little White Girl
1864

Intellectually, one would like to derive a metaphoric moral from this painting: loneliness, reflection of rejection, acceptance of fate, meditation, whimsical daydreaming, vanity, etc. Truthfully, intellectual derivations are pointless because there is no storyline. Simply, it is a picture whose value is the picture itself – a true rebellion against anecdotal fiction. There isn't any sentiment. Yet, this singular fact was difficult for Whistler's contemporary critics to fathom as, defensively, his art was quite unexpected and quite out of synchronization with the Victorian Age. A picture without a message was hard for them to digest, as it didn't speak to them. To comprehend a picture created solely for the intent of an arrangement, or for its own sake, requires the viewer to devoid himself of thought and to subtract his conscious of the depictions that they see, and what they had formerly accepted as a true representation of action and consequence. What should be is not. What must be concluded is not. Representation becomes nonexistent. Things and flesh placed within Whistler's frames exist exactly for the reason that that happenstance allowed objects and flesh to be where they are simply because it so happened. That was his genius. The creation of the art form and etchings was achieved through hard work and through numerous experiments: placing objects and models everyplace until they became suited to their environment and toward his vision. A placement here and there, with no false intrusions. This art form is said to be *Oriental* because the Japanese similarly placed objects and flesh with minimal interference. A great absence of background was required, and the effect of a few economic lines was the essential establishment of the picture. The Oriental inspiration can be established through Jo Heffernan's fan – yet, could it not also be established that the Oriental influence was there just because Whistler desired it to be – or perhaps it was his own private joke against himself?

In London, Whistler truly came of age. His drawings, relishing within their borders the lifestyles of the Thames River, brought his perception to an acute marvel that despite his intent, ran counter to the established art form of the age. Ironically, though his paintings refused to tell a story, he himself was a grand entertainer of mischievous conduct during parties and at work. Paradoxically, his life-style was flamboyant, styled with loud clothes, a monocle, his singular lock of gray hair, his long cane, and yet his paintings were muted and sparse, utilizing empty space that came to speak profusely and voluminously of an inner essence that few artists could capture. His art became a revolt against realism, turning to concrete brevity, presaging many later art movements. Natural light effects were abandoned and attempts to recreate nature were hissed upon, and to create a portrait was to create an arrangement rendered through a balance of colors and line movement. The sitter was secondary to the task at hand.

But as he rebelled against the establishment, they also fought against him. His critics were harsh. They labeled him as an eccentric, prone to misbehavior. He, on the other hand, did not care how he displayed himself in the public's eye. This appearance, though, always caused the untimely confrontations with society at large, as well as the judicial systems of the world. No matter how right one might be in one's mind – ultimately, we must merge ourselves to act in accordance with the world.

Finally, his antics and vanity came into direct conflict with the standards of the world. Whistler, in one of the art world's greatest trials, sued one of his critics, John Ruskin. The trial became a moral victory for painters because it established the legitimacy of non-representative art. A new fundamental understanding was acknowledged concerning the value of modern art wherein analogy and symbols were no longer required. "Art, for art's sake," or an art form that could be interpreted differently by different people: a subjective allowance based on an individual's experiences, feelings, and moods. The viewer could freely associate whatever carnations he desired. Various thoughts at various times became the sole requisite for art.

At age 54 Whistler finally married for the first time to a woman whom he could be socially comfortable with. She helped him to redefine his own greatness in the world. After a few years he determined to lecture and his "Ten O'clock" speech reinforced the credentials of the newly developing art form.

Not only did Whistler enlighten us with his brilliant conceptions, but he also gave to the museum gazers a new way of viewing art. It was he who created diffused lighting displays and gave each painting a generous amount of wall space – ideas for which he was forced to resign from the Royal Society of British Artists. I'm sure he walked out laughing.

Arrangement in Gray and Black #1:
The Artist's Mother

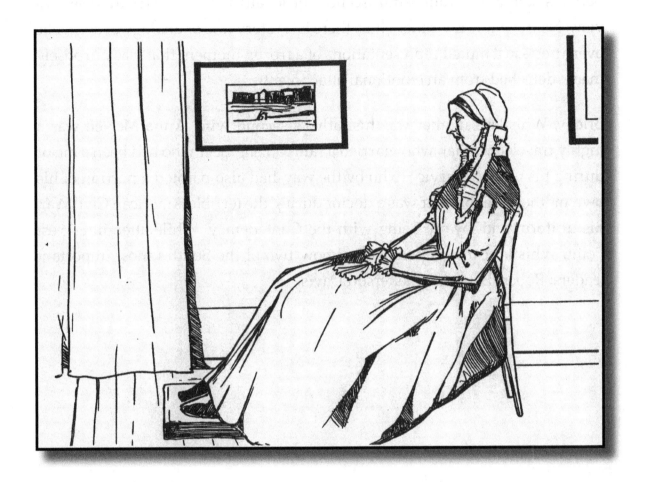

Drawn in Europe by the expatriate Whistler, this portrait nevertheless became the United States most famous painting – and indeed – one of the most familiar drawings the world has come to know of an actual person. Through the years, however, the painting's original intent was propagandized to symbolize many ideas and notions that Whistler had never intended: patriotism, maternal goodness, self-sufficiency, saintliness of motherhood, and offspring reassurance of paternal love. Its true conception was actuated solely for the arrangement's value, alone with its color/line emphasis with his mother placed in the room simply because it suited his purpose. The true greatness of the painting rests in the soft, attentive colors and in the placement of the sitter beside the wall wherein she came to harmonize an arrangement between object and flesh. The sitter is meticulously drawn: the color, line, pattern and composition being the

key elements. Whistler sought to create an effect of affect that whosoever viewed the picture would feel from it whatever subjective notions he personified, perhaps stemming from reminiscences or idealization or a strictly objective view. Neither view is wrong. Thus, there is no story line or analogy or symbolic overtures – just muted representations of a frozen moment that was purposely made, detached from an emotional attachment.

Briefly, Whistler's mother was his father's second wife. Anna McNeil was a highly traveled woman who married a railroad engineer who had been a major during his military service (who by the way, had also painted a portrait of his own mother). Her brother was a doctor during the terrible American Civil War, his uniform and loyalty being with the Confederacy. While attending West Point, Whistler came to personally know two of the South's most important leaders: Robert E. Lee and Jefferson Davis.

Rembrandt van Rijn

Usually, it may be difficult to understand Rembrandt's greatness. His work sometimes appears muddy and caked in too dark a somber mood. This misunderstanding encompassed the entire historiography of his purpose in art. It was a function not to stress exactitude, but to convey the emotions and undercurrents of humanity by stressing their ordinariness. His style sought to penetrate a person's thoughts, capturing forever a revelation of man's intent and purpose on earth. This purpose was reenacted through Biblical events, corporate portraiture that served to illuminate the participants in acts testifying to their personality composition, and through landscapes that conveyed romance and that juxtaposition Calvinistic and Mennonite philosophies actuated with true Jewish participants in the pictures that brought about a visionary scope, accentuating man's relationship not only to himself and his neighbor, but also to nature.

These works were committed in the Baroque style with his emphatic diagonals focusing attention to specific areas of concentration, rendered with brevity of brush strokes.

Misunderstanding also surrounded his real life. He did indeed suffered financial bankruptcy in 1654 due to his mismanagement of his earnings, and he did lose popularity as the Dutch citizens began turning their tastes toward tranquil landscapes and serene, complementary portraits of themselves. Still, his work continued to enjoy moderate success and with his new money he was able to renew his old purchasing powers, he died comfortably, and not in abject poverty, which could have been his fare.

Self Portrait

His younger years were kinder to him, however. His ability and popularity enabled him to buy expensive clothes and jewelry and he attempted to live the rest of his life in a fabulous house in Amsterdam.

Like Rubens, he manufactured replicas of his work, reproduced through copper etchings, for the common people. His marriage to Saskia brought him great wealth and allowed him to mingle with Holland's great landlords and nobles. Yet his life became filled with numerous tragedies. His wife and three children died of tuberculosis as did his mistress. Grief and sorrow became his neighbor, but with each downfall his personal integrity rose, enriching his canvases with a greater nobility and maturity. More dignified humanity emerged from the depths of the canvases. His life's course was reflected through over 90 self-portraits, each an aspect of life's existing impact on his personality. He was born in Leiden on July 15, 1606 of the United Netherlands and died on October 8, 1669 at age 63.

Tobit and Anna
1626

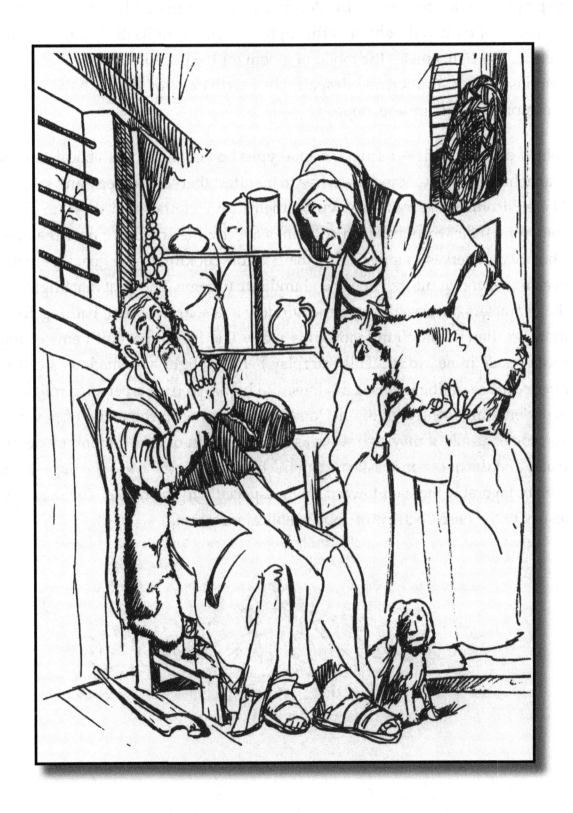

This painting was completed when Rembrandt was 20 years old. In it there are four emotions: grief and supplication by blind Tobit for his wife; Anna displays bewilderment, while the dog displays a face and body that is rendered in shades of dark and light. It is this light that manifest itself throughout the picture. The light creates the mood of gloom for the occupants of the house. It demonstrates destitution and despair. The fourth emotion lies with the goat. It is complacent. It manifests hope.

Tobit is a character drawn from the apocrypha books, and as the Biblical version is anachronistic, Rembrandt feels free to manifest their chronology and setting. The environment is cold – shown by their heavy clothes and they are poor, shown by their worn and torn coverings and by the small fire near the dog. The fire also serves to foreshadow the possible cooking of the goat – perhaps even representing future hope and abundance to come. The light that brightens the characters diffuses through the window at a sharp descent, bathing Tobit more so than Anna, illuminating his piety. The less important items of the room reside in near dark. This interplay between light and shadow is called *chiaroscuro*, revealing intense emotions, and in this picture, a personal religious experience and control of dignity and long suffering in the midst of poverty. Yet, conjecturally, it may also serve as an illustration of man's attempt to learn truth, and the question is asked – can the blind see truth? As to the dog – Jews are not favorably inclined toward them, especially in the house. The dog may testify to the false doctrine of Tobit's Biblical insertion.

Michelangelo Buonaroti

In the light of original talent, talent that comes from the very depths of one inner being, what one learns from his predecessors nearly becomes meaningless. This is not to say that the pupil becomes greater than the teacher, but that the teacher, giving inspiration to the pupil, allows him to flourish beyond the scope of his lessons to the realms of visionary insights that surpass experience and environment. Michelangelo trained under the great sculptures of his time: Ghirlandaio and Bartoldo, but the summation of their knowledge could not foresee nor endow him with the manifest projects that he was to commit to. Even the men which he was directly in contact with: Raphael and Leonardo da Vinci could not entreat Michelangelo with any sort of profound influences that would ultimately shape his artistic views. What Michelangelo developed came from the innermost depths of his own imagination, giving birth to the most incredible painting and sculptures of our civilization.

The plasticity of the human body, its technical prowess, its esthetic vitality, is finely captured in Italian marble, seeming to move and to have emotion, expressing human frailty in such a dramatic vein that the viewer is compelled to actually believe the marble is alive with pulsating blood and a heartbeat.

Yet his genius was not limited to the manipulation of the hammer and the chisel against the marble stone, for like his greatest competitor, da Vinci, Michelangelo triumphed in the realms of architecture, poetry, and painting: becoming in fact during his own lifetime, the epi-center of artistic genius. His talent was so vast his contemporaries nicknamed him "The Divine Michelangelo". Thus, if ever a man could be said to be the idea representative of an age's merit, Michelangelo would have that honor.

And even though we say such a grand thing about this wonderful artist, we must still recognize the fact that this was not a man who approached living life easily as his vast talent placed him tin the courts of 13 Popes and countless important princes and governors – all who had to learn to tolerate his confrontative nature that was punctured with extreme mood shifts: from generous down to sarcastic. Blunt to withdrawn. Humorous to violent rages. He also became infamous for his lack of bathing and for his long periods of not eating a nourishing meal. Often these extremities forced him to single-handedly complete many of his assigned projects as no one could long tolerate his manic shifts. The consequences of his isolation, however, had the effect of producing for him an intense concentration, and, similar to Beethoven, this silence nurtured an intense profundity that became unrivaled in the artistic world.

Privileged talent in itself, though, did not excuse his extremities of behavior. Genius, on whatever level, should not create distance and disregard for others. To belittle another is a vain dishonor and loathsome glorification of oneself. However, he was fortunate to have been raised in the Medici Palace – Florence's foremost leading family. He grew up with men who would later formulate their ambitions toward achieving a Pope's reign. He also became intimately acquainted with powerful men who desired his personal interpretation of large scale Biblical epics and, through his eyes, ordinary men came to appreciate a new vision of religious and human interaction that had seemed to become lost in the wake of the struggling reformation movements sweeping throughout Europe at that time.

Moses
1513 - 1515

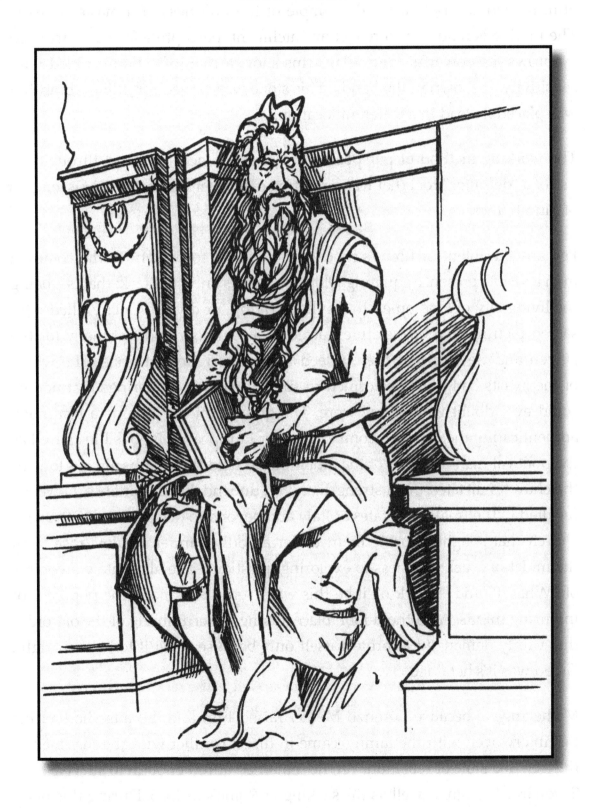

The horns that Michelangelo carved over the forehead resulted from a mistranslation of the Vulgate Bible. The true interpretation is "lightbeams". Still, the stonework is a vivid example of the fluidness of a master's talent. The marble is rendered to reflect an intelligent, perceptive face: its furrowed eyebrows, its powerful, muscular arms show a man of action coupled with sensitivity as shown in the hands. This stone was carved for Julius' Tomb, but was placed instead in a different location.

The working method of perspective carving was accomplished through the use of a "definitor" tool that was a rotating disk ruler that held carious lengths of plumb lines.

Perhaps the intent of Rome's modernization was to present to the common man a visible presence equating Old Jerusalem 's anointed task: that is – being the living city of God on earth. In that striving for divinity, a city filled with sacred pictures and epic statutes, acted as a reminder and testimony for the citizen and traveler that they indeed approached God's throne. The works of the artists had to be performed in such a majestic renderings that no one could ever doubt where they were. The grand projects became a testimony authenticating the church's dominance over European religious life as well as the political manifestation of the ambitious to hold their paths always toward the church's dictates. Such strength and an unbendable dominance, however, resulted in the small city-states of Italy and beyond to declare war on the very church that sought to unite them under a godly banner. Zealots rose from the midst of cruel blindness to exploring questions. The alternate viewpoints of "What if" and "Shouldn't it be this way?" erupted among the populace of inquiring minds. A foothold took place among the crumbling of the old order that vainly demanded to protect itself only because it felt it to be their right. Greed was it's heralded cry.

Michelangelo, because Lorenzo Medici raised him and, because he had his ties interwoven with the family, came in direct conflict with the madmen of the frenzied state of rebellion. Yet, he remained adroit enough to survive both Savonarola's reign as well as the sacking of Rome's in 1525. During this bitter

period of confusion and shouts of prominence through the rights of inheritance and godly appointments, Michelangelo created his supreme masterpiece: the painting of the Sistine Chapel. At one time this very same building was the resting and feeding ground for the soldiers' horses. His troubles, however, were not just limited to the "madmen" of the world, but also against zealous Popes who vainly sought to restore order and control under their own national banner. Ironically, his architectural talents led him to defend his home city, Florence, against the charging brigades of Pope Clement. Michelangelo's defensive designs were so impressive, they were imitated throughout the coming ages by modern armies who sought to defend their own bases and forts.

Philosophically, Michelangelo was inclined toward the Neoplatonic thought. They believed that all things were situated as a tight mass – a solid – and that human emotions were actually an imperfect representation of the Ideal Form, which is manifested by the existence of pure spirit. The human soul emerged from this Ideal Realm and while alive has distinct yet minute memories of its former being. Thus, knowing a sense of former things, a living person becomes dissatisfied with the present condition – and only in death – can his soul be restored to the Ideal Realm – but – only if while he was still alive on earth he strived toward a good, true, and beautiful life.

These thoughts encompassed the age of the High Renaissance of which Michelangelo was the leading example. Such evidence of his leadership is viewed in his paintings wherein his linear perspective dramatically differs from the flat tones of the Middle Age's paintings. His paintings came to life with interplays of color and light and with active people engaged in and demonstrating true emotions – not a flat response wherein hidden symbols were the intellectual play of the courts, distanced from the common man's possible comprehension.

Pieta
1498-1499

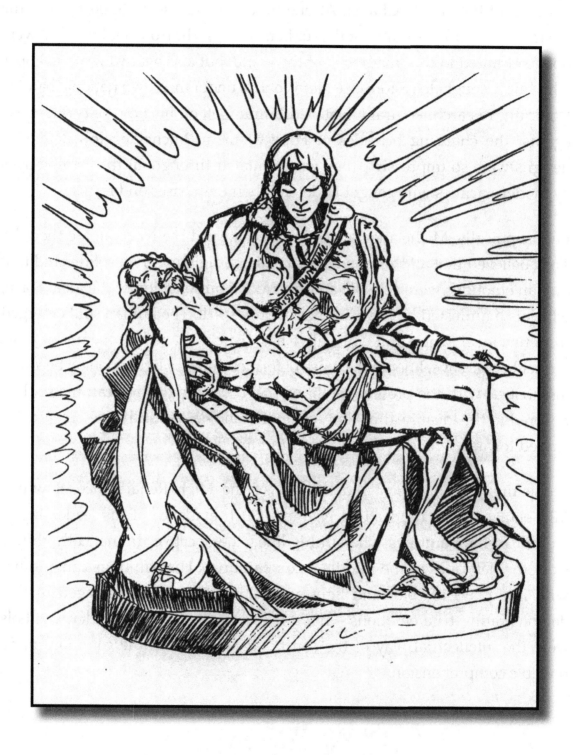

The Reverend cardinal of San Donigi commissioned this work. It took Michelangelo a year to complete. He was 24 years old when he received the assignment.

In this work we see the actual embodiment of Michelangelo's Neoplatonic philosophy: the physical beauty being the true manifestation of the noble spirit of mankind.

The Pieta was carved from a single piece of white marble. The figures, though disproportioned to actual human beings, is nevertheless one of the greatest statues ever carved by an artist. It is the supreme representation of a mother's deep love for the death of her child, and the resultant loss for the total of humanity. It is a universal plead for the continuance of life. The woman personifies beauty and innocence, thus accounting for her youth.

Truthfully, the real Mary was in her early fifties when Jesus was murdered on the stake. The line carvings of the statute display an extraordinary comprehension of anatomy as the stone appears to breath. As one looks you can actually believe you are really looking at a scene stolen and frozen from time in eternal stone. It depicts the utmost sensitivity of acceptance of a son's death, perhaps with an uncanny realization that this particular death brings with it an expectation of greatness for man. The intricately carved draperies that flow about the bottom of the statute display a vibrant sense of movement. It serves to unify the work in thematic conclusions of the return to the Ideal Realm.

Jean Baptiste Simeon Chardin

Chardin was a French painter who specialized in reproducing *still-life* art forms. Still-life is the drawing of inanimate objects: food, hairs, kitchenware, and arranging them in pleasing settings wherein the viewer takes comfort and delight in seeing them. An aesthetic beauty of form and function is achieved through color balance, shadow and light play on the object, and the depthless or lightness of the brush stroke. Chardin, in this art form, was the best.

By viewing his art one has to look at his brush strokes. By observation the meticulous brushstrokes are realized: they evolve on the canvas from smooth to rough in an almost indistinguishable advance like a flat valley that gradually, almost imperceptibly becomes mountains. The texture of his paint evokes an uncanny display that makes the viewer believe he is actually at a real object. A transcendent shift from one plane of reality to a harmonious concept of a variant plane of existence that is rendered ideally and eternally. His food painting can actually make your mouth water. His kitchenware appears touchable.

This magic was accomplished through the mastery of illumination and shadow. His art works has a sense of dimension.

Chardin was born in 1699. He lived for 80 years. He died in 1779. During his lifetime he practiced thrifty, hard-working values. He was careful in the exactness of his paintings- his hand was never lazy. The high details of everything are quite remarkable. Unlike a lot of artists, he did achieve fame during his life and he earned a very comfortable living at what he enjoyed doing.

In addition to hi still-life paintings, Chardin was an expert at painting people. Yet, he preferred to engage himself with the flowers and vases and utensils more so than with people. It is true, however, painting people earned more money for the artist than still-life. Many of his own peers engaged profusely in painting people because of that singular fact. But for many, the pleasures and importance of realized integrity is more important that the gains of money. He wanted to remain true to his ability.

That is what he wanted, and that is what he accomplished. He did not surrender his value for the love of wealth. As we view his paintings, we can see how his brushstrokes interacted with the diffused light to create a tranquility, which became his trademark. As can be seen, he was an outstanding master in the composition of *delimited space*.

Still Life With
Grapes and Pomegranates
1763

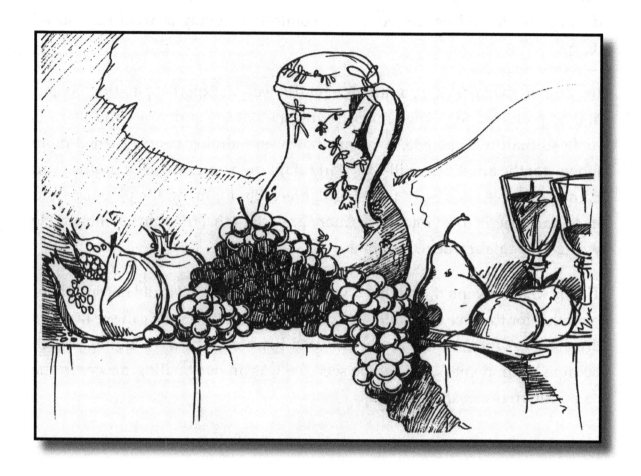

Here the bitten fruit appears succulent while the grapes tempt us to step forward and partake from their stems - an invitation that cannot be refused. It is like a man has found peace and comfort in the midst of happiness, with a plate of delicious fruit that will never rot or be completed consumed. Nourishment is eternally provided. This ability to capture a viewer's attention compelled Chardin to draw his preferred selections. The painting is not a mere object hastily drawn, but a painting pulsating with vigor and with life and with richness and grand variety.

The two wine cups brings humanity into sumptuous companionship, the beautiful vase with leaves that shall never wither is promised to never run

out of good wine. Perhaps that what life should be: to own a field forever and forever where a loving couple can build their house as they desire with a table full of food and ultimate satisfaction. What greater peace?

The Copper Cistern
1733

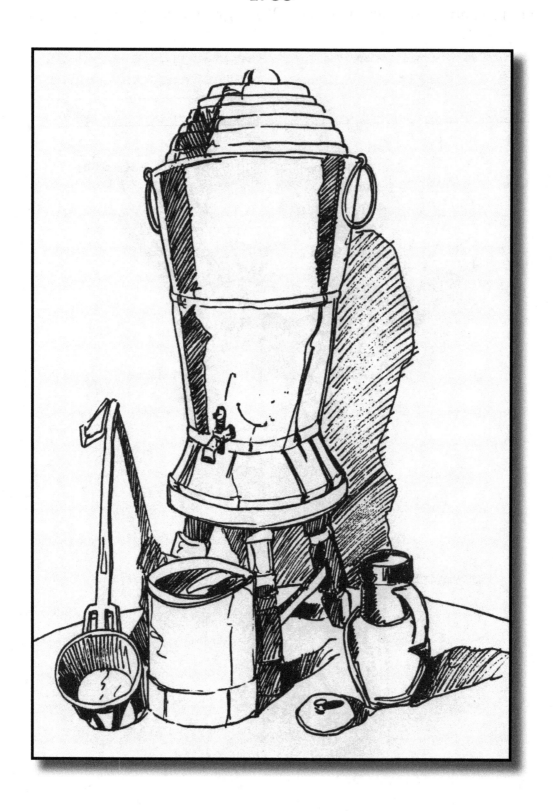

The cistern and jug and ladle and bucket actually belonged to Chardin. He employed them on a continuous basis not only for the carrying of water to quench his thirst, but more important, to eternally quench the thirst of mankind. The objects of survival appear to be set away from the wall, through the play of light and brushstrokes that lead the main piece further away the other pieces. The painting represents three dimensions: depth, wide, and height. It is accomplished through a mastery of fine lines and the usage of shadow.

Joseph Mallord William Turner

Perception perceived through genius can at times defy conventions. Standardization is stagnation. Turner, with his ability to enshroud nature as the manifest entity in which man must abide within, created an aura of bright colors that represent an imaginary world that had been previously unseen by any other artist. A world of such intense etherealness of red and oranges that it came to contribute significantly toward the output of impressionistic artists of the following decades after his death.

The luminous effect that he had created through the evanescence of colors in his painting, however, became something quite unexpected during his lifetime for his peers to gaze at. Nevertheless, though the paintings were quite different from the other popular artists, he was not shunned as an outcast. Indeed, during his own lifetime he was accepted as a brilliant creator of a far vastly unique vision that was wholly his own.

Yet the lightness and near iridescence of his colors that appeared to worship sunrises and sunsets contrasted directly with the chiaroscuro of the past great artists who were fully accepted by British society. And, to create further contrast between himself and the past artists, Turner specialized in using in his epic

renderings single, unified circular motions, swirls, and vortexes which drew the viewer's eyes to the centerpiece of attention on the canvas rather tam the tri-sectional division that had been effectively established by the other artists.

Turner began his art career, however, on a common level base representative of his peers. Like them, he performed his first works through the strict conventions of the British art world. Only after years of experimenting his painting with watercolors did Turner dare to venture into an arena that would heighten into experimental mists of forms.

He was born on April 25th, 1775. Turner lived his early childhood in dismal poverty. His father was a barber who would later become his son's most important companion and personal caretaker while his mother came to suffer extreme self-inflicted guilt persecutions that eventually led to her death in an insane asylum. This happened to her because she blamed herself for her only daughter's tragic and youthful death. For these events, Turner determined to keep his life a private affair. He restricted himself to a few friends and insisted on maintaining two separate houses far from each other for the two women who became his mistresses.

As with all great artist, devotion to hard work, meticulous and time-consuming practices with a consideration devotion to the realization of his talents, Turner was able to succeed with the British art buyers. He gained wealth, fame, traveling adventures, and became Europe's renown artist-in-residence.

By the time he was 14 years old his vast talents led him to the Royal Academy School. Ten years later, at age 24, he became an associate member of the Royal Academy of Arts. When he was 27 he achieved the rank of full membership of that society. Unfortunately, his vast and dynamic talents rested solely within his own self. Turner's talents could not be taught to others. He did not have the flair of an inspirational teacher though he was a paid counselor to teach and to impart and to enhance his students' own talents toward their own canvases. In this respect, Turner failed. A gifted man, for all his keenness, could not teach.

Nevertheless, because he stayed on the conservative path during his embryonic years and remained within the confines of the conventional wisdoms of British art society, he was accepted and permitted to flourish. Once, however - and this is the important aspect of his life – he reached full stature in the traditional aspects of his station – he turned his gifts to the full bloom of his genius. His paintings began to manifest hints of contrast – hints against norms – hints that would evolve into full-scale emancipations of bright colors that told stories of man's inability to conquer nature. The tranquil landscape was not so generous to the temporal occupant. Nature, through whims of wind and clouds and heat and cold, through upheavals and calm, was a never-ending cycle of indeterminate challenges. Man, residing with nature, was not the conqueror, but rather, was a placement within its play: man's cause and effect – the progression and regression, set in motion in the universe by the whims of nature's variant functions. Who can tame what cannot be conquered?

Manor House Gateway
1798

This house was painted in the watercolor medium when Turner was 2 years old. He rendered it through the usage of muted earth tones of brown and gray. The large expanse to the right is rendered in soft hints of yellow effectively hidden within the subtle gray somber of sunlight's filtration from the high clouds to the English manor. Light beams gently touch the ground as well as the lower walls of the manor, painted with a deft muted and softened brushstroke.

In turner's later years color became the drama of his art. Color intensified emotions and set moods. Color became the atmosphere of man's existence. The atmosphere of climate: rain, snow, heat, and fire. The atmosphere and climate of sea, land, and mountain captured his imagination and impregnated his memories with unforgettable details that came charging out of his mind onto the canvas that was drenched with numerous base coats of white topped with pinks, yellows, and subdued earth tones.

In contrast to his contemporaries he did not desire to render photographic accuracy of the interplay between man and nature and the things that build erected on the face of the earth. After all - houses, bridges, roads, castles, ships are all temporary objects set falsely upon an earth that is never predictable nor tamable. His produced art demanded a rendering of the visual conflicts inherent between true existences versus the false pursuits of man's vain attempt to calm things to a regulated fixture. Landscapes had to represent a stimulus of emotions accentuated through the usage of vibrant reddish and brown colors. Turner's intent and quest was to bring the viewer to the very forefront of the confrontations of life set against dramatic turmoil – the viewer became the undeniable witness to the possible rages of uncontrollable events. History and nature make their impacts only because there was someone there to testify to it. Man, for all his progressions, can never hide himself with the blossom of a tranquil nature or within the softness of bliss – because the tides of change always sweep against such hopes.

Still, despite this unconventional quest, his work became very popular. He managed to earn a very good living through his book and magazine drawings. He also replicated numerous paintings that made him an extremely rich and popular artist.

The Fighting "Temeraire" tugged to her last birth to be broken up.
1839

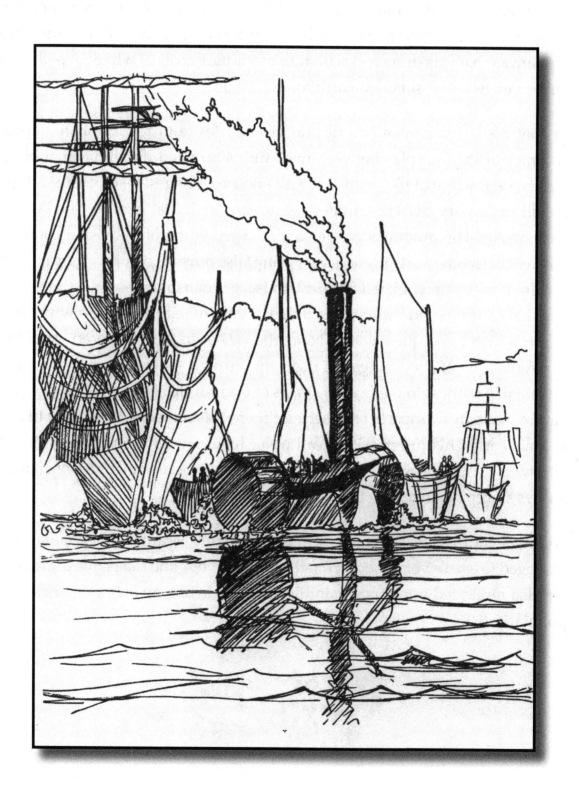

The steam tug boat that had recently been invented is pulling one of the grand ships of Admiral Nelson's fleet that had once fought Napoleon's nay in the Battle of the Nile in 179 and again at Trafalgar, Spain. It was this ship that avenged Admiral Nelson's death during Trafalgar's grim battle during which half of France and Spain's ships were destroyed while Nelson lost none.

The Temeraire was equipped with 98 great cannons. In this picture the ship is being hauled away from its resting lace at Sheerness, England. Before she was tugged away she was given a final cost of paint, which of course, Turner refused to enliven as his emphasis was not the death of the ship and its honor, rather, Turner wanted to create bold colors that would arouse emotional excitements and temperaments. Also, it should be noted, the new technology is dragging away the old, obsolete technology. However, instead of triumphing the arrival of the new and better, both ships became partners of each other – both are duly drawn in veils of translucent mists that render both into an ending era that is without paradox. The painting calls for a recognition of the world's rapid advancement in new things that must also someday face its own demise. All era's end, all modern things become obsolete. The ages of man are nothing but a passing from one cloud to another. From one storm to another.

This painting became England's grand expression of its national glory. It also became Turner's most popular work. National symbolism took over the work's intent. In it, the viewer came to see the dignity and pride of England. The viewer forgot that he was looking at what was once a vicious war machine responsible for the deaths of hundreds of men. More, as powerful as this war machine was, what is it compared to what comes afterwards? As elusive as nature is, so it appears, peace is also an elusive goal.

Other Books By Walter J. Schenck

Shiloh Unveiled: 2 Volumes
– 1,382 pages -

First Voices: 3 volumes
– 1,082 pages -

The Birdcatcher: 2 Volumes
– 804 pages -

The Final Comparative to the Synoptic Gospels: 2 Volumes
- 1,202 pages –

Reign of the Madman: The Birdcatcher
- 400 pages –

Jesus of the Four Gospels
- 233 pages –

Handbook of Jesus' Parables
- 104 pages –

The no-nonsense, straight-to-the gut,
CCNA 2.0 Study Guide
- 408 pages –

The Birdcatcher: 30th Anniversary Revisit
- 609 pages –

NOTES